PITKIN COUNTY
library

inspire growth

PITKIN COUNTY LIBRARY

1 13 0003125719

120 North Mill Street • Aspen, CO 81611 • 970-429-1900

WITHDRAWN

779 G248 22.95
Gaskell, Anna.
Anna Gaskell

D0897093

Anna Gaskell
by proxy

New Work 2: Anna Gaskell
August 11 – October 15, 2000

This exhibition and publication were funded by the AAM National Council.

Copyright © 2000
Aspen Art Museum
590 N. Mill Street
Aspen, CO 81611
(970) 925-8050
www.aspenartmuseum.org

Designed by Linda Whisman

Edited by Karen Jacobson

Printed by Congress Printing Company, Chicago

ISBN 0-934324-28-X
Library of Congress Control Number: 00-134807

Cover: *Untitled #60 (by proxy)*, 1999
Page 6: *sunday drive*, 2000

Anna Gaskell
by proxy

ASPEN ART MUSEUM

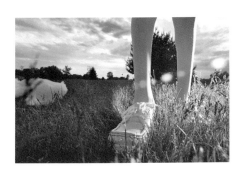
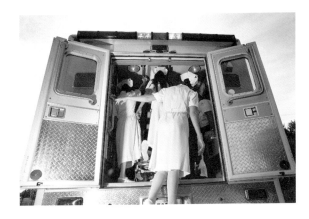
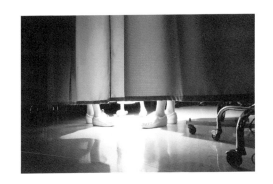
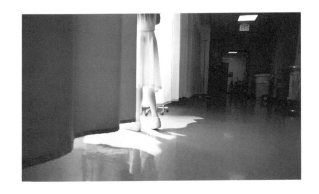
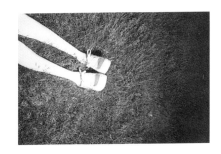
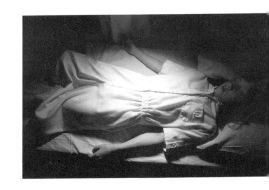
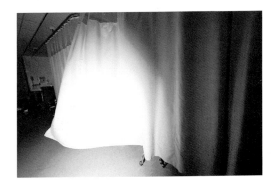
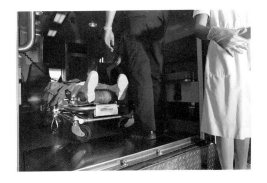

Preface and Acknowledgments

The Aspen Art Museum takes great pleasure in presenting selections from Anna Gaskell's most recent photographic series, *by proxy*. Gaskell is one of the most celebrated and highly discussed figures within an emerging group of young American artists who work in the medium of large-format color photography. Like many of her contemporaries, Gaskell seems to draw inspiration more from film, television, and mass culture than from traditional art or photographic history. When Gaskell and her peers are considered alongside young artists from other countries who work with color photography—Thomas Demand (Germany), Rineke Dijkstra (Holland), Annika von Hausswolff (Sweden), Tracy Moffatt (Australia), Mariko Mori (Japan), Sam Taylor-Wood (U.K.), and Wolfgang Tillmans (Germany/U.K.)—as well as more established figures like Andreas Gursky, Cindy Sherman, Thomas Struth, and Jeff Wall, it becomes clear that photography has moved from the periphery of the art world to the center stage.

Although Gaskell's work has been included in more than forty exhibitions in the past five years, this is only her second one-person exhibition at a U.S. museum. We are particularly delighted to be presenting the first museum showing of her *by proxy* series, on the basis of which she was awarded the prestigious Citibank Private Bank Photography Prize earlier this year. Although our exhibition includes just eight examples from the series, we felt that it was important to reproduce all fifteen images so that this publication would be a complete document of this extraordinary series.

This exhibition joins other memorable one-artist presentations organized by the Aspen Art Museum at critical moments in the artists' careers. Artists who have been featured include Shigeko Kubota (1979), Susan Rothenberg (1984), Jenny Holzer (1987), Alan Rath (1996), Nancy Rubins (1997), Tony Oursler (1997), and Ilya Kabakov (2000). The present exhibition, which is the second installment in our New Work series, continues the museum's commitment to presenting the work of the most significant and exciting artists of our time.

I am especially grateful to the AAM National Council for its support of this exhibition. Casey Kaplan, the artist's primary dealer, was enthusiastic about this project from its inception and was helpful throughout the organizational stages of the exhibition. I would also like to acknowledge Muriel Quancard for her assistance. National Council members Debra and Dennis Scholl, longtime supporters of Gaskell's work, were particularly helpful as the exhibition was being developed. They—along with Marco Brambilla, Casey Kaplan, Frank Moore and Nina Robbins, and Jeanne and Nicholas Rohatyn—have graciously lent works to the exhibition.

The entire staff of the Aspen Art Museum contributed their talents to this exhibition. I would particularly like to acknowledge Linda Whisman, who is responsible for the design of this publication; Catherine Murphy, registrar, who organized the transportation of the artworks; and David Marsh, preparator, who worked with me on the installation. I am also grateful to Karen Jacobson for her careful editing of the texts.

I would like to give my final thanks to the artist. I am especially grateful to Anna Gaskell for her interest in the Aspen Art Museum, her willingness to collaborate with me on this exhibition and publication, and her timely responses to my numerous requests.

Dean Sobel
Director

Introduction

Dean Sobel

By proxy, Anna Gaskell's series of fifteen color photographs, is a continuation of the artist's exploration of the fears and uncertainties that are a universal aspect of human experience. Like all her earlier works,[1] *by proxy* features young female models, multiplied as generic "types," acting out situations that appear to be inspired by a narrative premise yet whose significance remains unclear. Although children frequently appear in Gaskell's photographs, her work is "about" childhood only to the degree that childhood can be seen as a metaphor for the more vulnerable, unformed aspects of the self. Gaskell's first two series, *wonder* (1996–97) and *override* (1997), refer to the hallucinatory, oftentimes sinister events Alice experiences in Lewis Carroll's *Alice in Wonderland* and *Through the Looking Glass*.[2] Her next series, *Hide* (1998), is based on a little-known Brothers Grimm tale called "The Magic Donkey," in which a child avoids the advances of her father by disguising herself with animal hides. Gaskell's most recent bodies of work, *Sally Salt says* (1999) and now *by proxy* (1999), feature Sally Salt, the female protagonist and narrator of *The Adventures of Baron Munchausen*, a recent film based on the fantastic stories of the exploits of the eighteenth-century German baron Karl Friedrich Hieronymus von Munchausen.[3]

In *by proxy*, rather than taking inspiration solely from fictional or historical sources, Gaskell also deals with factual contemporary events. The protagonists in *by proxy* are an amalgam of Sally Salt, Munchausen's gullible and adventuresome companion, and a more notorious and dangerous character, Genene Jones, a real-life pediatric nurse who was responsible for the murder of several children in Texas in the early 1980s.[4] The characters in *by proxy* wear white nurse's uniforms, and all are intended to represent Jones at different stages in her life. In a psychological sense, the conflict and struggle that undoubtedly raged on in Jones's tormented mind are expressed through these images of her essentially battling with herself.

The title of the series refers to Munchausen syndrome by proxy (MSBP), an unusual form of child abuse in which a caregiver, usually the mother, injures or induces illness in a child, perhaps in order to draw attention to herself.[5] First identified in 1976, this syndrome, along with the somewhat better understood Munchausen syndrome (in which someone feigns or self-induces illness or injury), is named for Munchausen because of his reputation for telling exaggerated stories of his experiences as an officer in the Russian cavalry. Gaskell's *by proxy* photographs, like Munchausen's tales, describe tremendous and nearly unbelievable events. The disturbing nature of the incidents depicted in *wonder* and *override* is mitigated by the viewer's awareness of their basis in fiction and fantasy, whereas the factual nature of MSBP and the Jones murders makes *by proxy* perhaps Gaskell's most unsettling body of work.

In its basic format, *by proxy* is similar to all of Gaskell's other series. Borrowing elements from film direction, set design, choreography, and still-life photography, the artist carefully arranges her models, props, lighting, settings, and point of view to create powerful single images. She frequently crops her compositions to frame limbs or other fragments of the models' bodies. Certain scenes are photographed from a low angle, with the camera placed near the ground, so that we view these images from the vantage point of a child.

Settings, backgrounds, hair, and costumes are all important elements in *by proxy*. The landscape dominates the composition in *Untitled #69*, where the figures are nearly absent. Dark skies, spindly evergreen trees, melting snow, and suggestions of twilight figure prominently in many of the images. Gaskell's backgrounds and horizons are often out of focus, imparting a surreal, dreamlike quality to her settings. The range of colors, however, is somewhat limited in comparison to much of her earlier work. White prevails throughout, and the sterile white nurse's uniforms (often spotlit) and blankets of fake snow give these images a chilly ambiance. Gaskell's choice of the forest, caught between seasons, as her stage is also interesting.[6] She depicts nature as a frightening, lonely, and uncertain place.

What is perhaps most unnerving about Gaskell's photographs is this uncertainty—what exactly is taking place? Figures move about, in a trancelike state, without any destination or purpose. Rarely do we see images of obvious abuse or violence (hair pulling and arm tugging may be the most aggressive acts actually shown). More commonly, the intensity in Gaskell's photographs is constructed in the viewer's imagination. This makes the images even more troubling, in that we are drawn into (and, in essence, take part in) these dramas. In *Untitled #63* and *Untitled #64*, for example, the figures are shown huddling over an unseen "victim" or event. Like horror filmmakers before her—particularly Alfred Hitchcock, who rarely depicted explicit violence in his suspense-filled dramas— Gaskell understands that what we don't see can be more frightening than what is made apparent.

Gaskell's work exhibits other influences from Hollywood cinema. Her protagonists resemble the innocent yet tortured young women in films like *Carrie* and *The Exorcist*, and her nightmarish settings and zombielike characters could be straight out of *Night of the Living Dead* or *Invasion of the Body Snatchers*. The texts she chooses to adapt (Brothers Grimm, Carroll) are similarly dark and are filled with bizarre situations rife with visual possibilities.

Gaskell has routinely laid out her "stories" in a nonlinear, disjointed manner. If one considers the numbered sequence in *by proxy*, however, the images seem to unfold to form a linear (and horrific) narrative. In the first two photographs, *Untitled #56* and *Untitled #57*, the figures seem to prepare for an unspecified activity as they wrestle with tangled stockings and knotted surgical gloves. In *Untitled #58*, we are introduced to a young child (probably no more than five years of age), who sits helpless while an older girl's hand squeezes her cheeks. In the next several images, the nurses band together and form frightening circles—as if their dastardly work has begun. Day turns into night in *Untitled #63* and *Untitled #64*, casting an even darker shadow on the unseen events taking place. A single figure is laid out in isolation in *Untitled #67*, the most overt depiction of death. *Untitled #70*, the final image in the series, shows a giant, upright nurse—her face covered by her hair—carrying away the small, lifeless body.

Hair has become a particularly expressive formal device in Gaskell's work. It is used most frequently to mask identity. By concealing the models' faces, she makes them into faceless, generic creatures. In *Untitled #61*, rich auburn hair cascades out of a model's mouth and onto the ground. Gaskell's emphasis on long tresses has frequently been linked to her interest in Victorian painting and the literature of late nineteenth-century England.[7] The Victorian era, which spawned many classic children's books (including *Alice in Wonderland*), was also the period when modern notions of childhood as a distinct phase of development and as a time to be enjoyed became more widely accepted.[8] Images of sleep, another common theme in Victorian art (especially in the work of Edward Burne-Jones and Frederic Leighton), also appear throughout Gaskell's art.[9] Her models, even when shown upright or walking, exhibit a distinct gait that resembles sleepwalking (see, for example, *Untitled #65*). Sleep is used as a metaphor to suggest an escape from reality and to represent the fragile zone between life and death (during deep sleep the body exhibits physiological symptoms similar to those experienced by the dying).

Although her work, in a formal sense, displays a high degree of realism and precise photographic technique, Gaskell's narratives often unfold in imprecise ways—through metaphor, allusion, and understatement. Her ambiguous images only hint at their literary and historical sources, and their meaning remains obscure. The somnambulant figures and surreal landscapes in *by proxy* suggest that her vignettes are not depictions of reality, but instead represent dreams (or, more accurately, nightmares). Gaskell suspends us in an uncomfortable place, somewhere between consciousness and sleep, the seen and the unseen, fact and fiction, the real and the imaginary, and—perhaps most frightening of all—heaven and hell.

Notes

1. Since 1996 Gaskell has numbered her works in a consecutive sequence, grouped by series. *Wonder* (1996–97) includes numbers 1 through 20; *override* (1997), numbers 21 through 30; *hide* (1998), numbers 31 through 47; and *Sally Salt says* (1999), numbers 48 through 55. The *by proxy* series comprises numbers 56 through 70. All titles take the following form: *Untitled #1 (wonder), Untitled #21 (override)*, etc. These five series were preceded by a group of single portraits of young girls (each with a different title), all intended to be portraits of Alice from *Alice in Wonderland*. These six bodies of work—along with two films, *floater* (1997) and *magicass* (1998)—make up Gaskell's entire "mature" oeuvre.

2. For an excellent discussion of *wonder* and *override*, as well as extensive reproductions from both series, see Bonnie Clearwater, *Anna Gaskell* (North Miami, Fla.: Museum of Contemporary Art, 1998).

3. Several publications of Munchausen's tales exist, including a rare edition with illustrations by Gustave Doré (New York: Book League of America, n.d.). Munchausen's legends were popularized through the film directed by Terry Gilliam (Columbia/Tristar, 1989). The character of Sally Salt was Gilliam's creation. By using Salt to narrate Munchausen's stories, Gilliam made her the single "voice" and, in many ways, the grounding force in the film.

4. Genene Jones was a nurse at a pediatric clinic in Kerrville (Bexar County), Texas. In 1984 she was convicted of killing fifteen-month-old Chelsea McClellan by injecting her with a muscle relaxant, which stopped the girl's heart. She was also convicted of seriously injuring a four-week-old boy and is suspected in the death or injury of other children. Though she maintains her innocence, Jones was given a ninety-nine-year sentence. For additional information, see Peter Elkind, *The Death Shift: The True Story of Nurse Genene Jones and the Texas Baby Murders* (New York: Viking, 1989).

5. For a discussion of MSBP, see Herbert A. Schreier and Judith A. Libow, *Hurting for Love: Munchausen by Proxy Syndrome* (New York: Guilford Press, 1993).

6. Gaskell shot all of the *by proxy* photographs in her hometown of Des Moines, Iowa.

7. See, for example, Clearwater, *Anna Gaskell*, 9–10.

8. See Cynthia Burlingham, "Picturing Childhood: The Evolution of the Illustrated Children's Book," in *Picturing Childhood: Illustrated Books from Southern California Collections, 1550–1990* (Los Angeles: Grunwald Center for the Graphic Arts and Department of Special Collections, University Research Library, University of California, 1997), 37. The many complex themes developed in *Alice in Wonderland*, including Alice's journey toward self-discovery and the blurring of fantasy and reality, are all relevant to Gaskell's work, suggesting that there is still much to be learned about this work and its relationship to late Victorian literature.

9. For a discussion of sleep imagery in Victorian art, see Allen Staley, "The Condition of Music," *Art News Annual: The Academy* 32 (1967): 80–87.

Plates

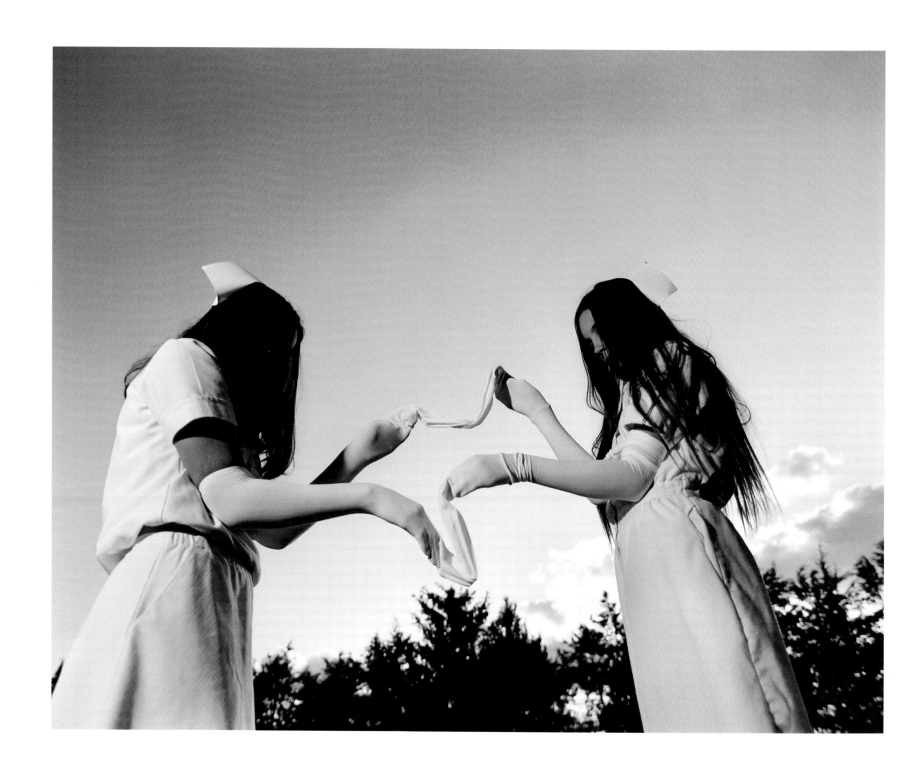

Untitled #56 (by proxy), 1999

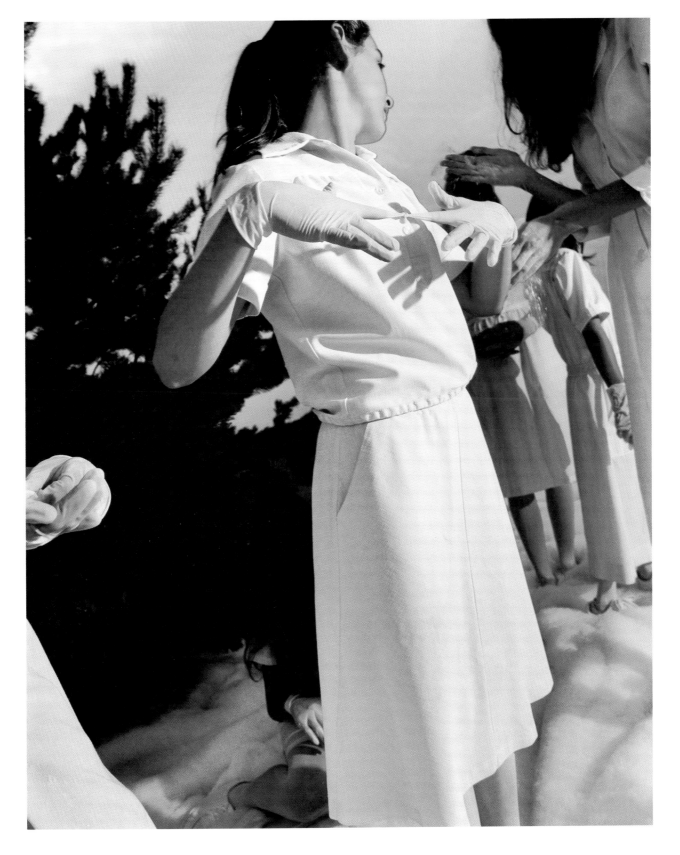

Untitled #57 (by proxy), 1999

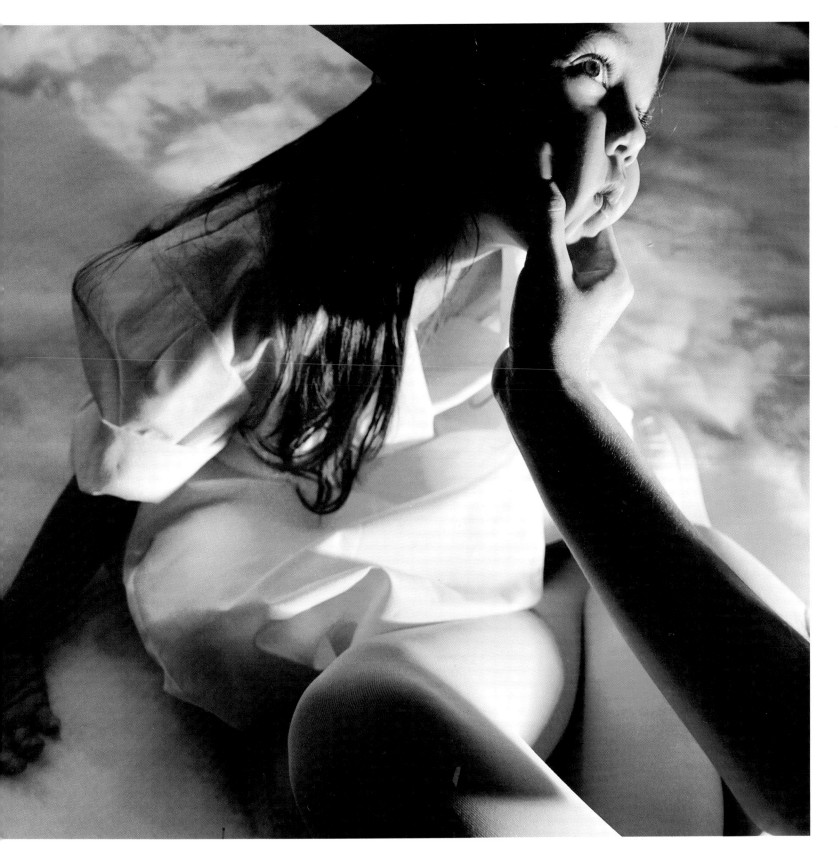

Untitled #58 (by proxy), 1999

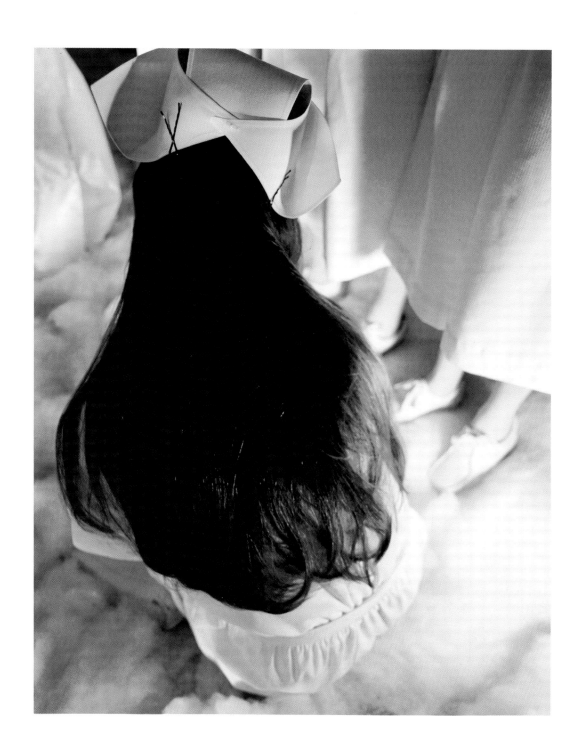

Untitled #59 (by proxy), 1999

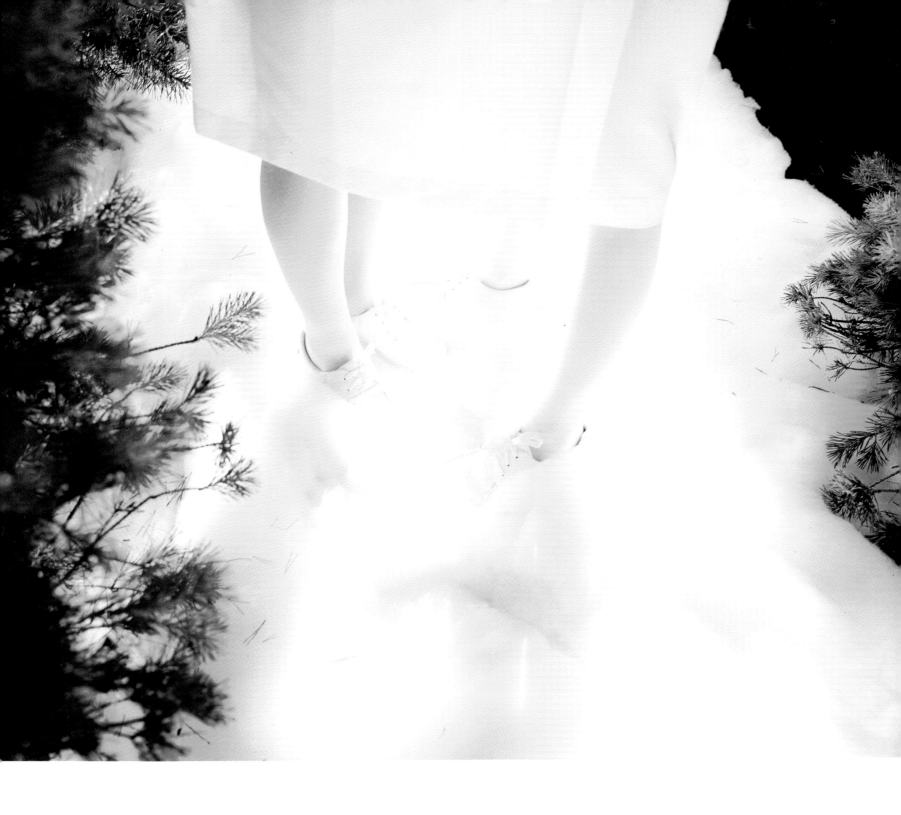

Untitled #60 (by proxy), 1999

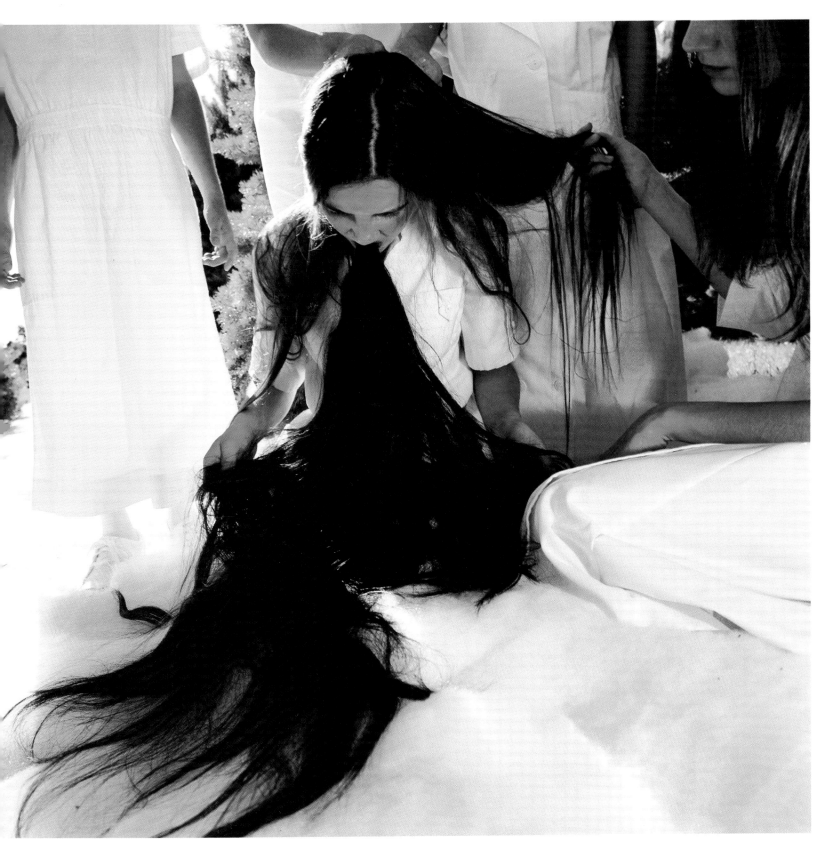

Untitled #61 (by proxy), 1999

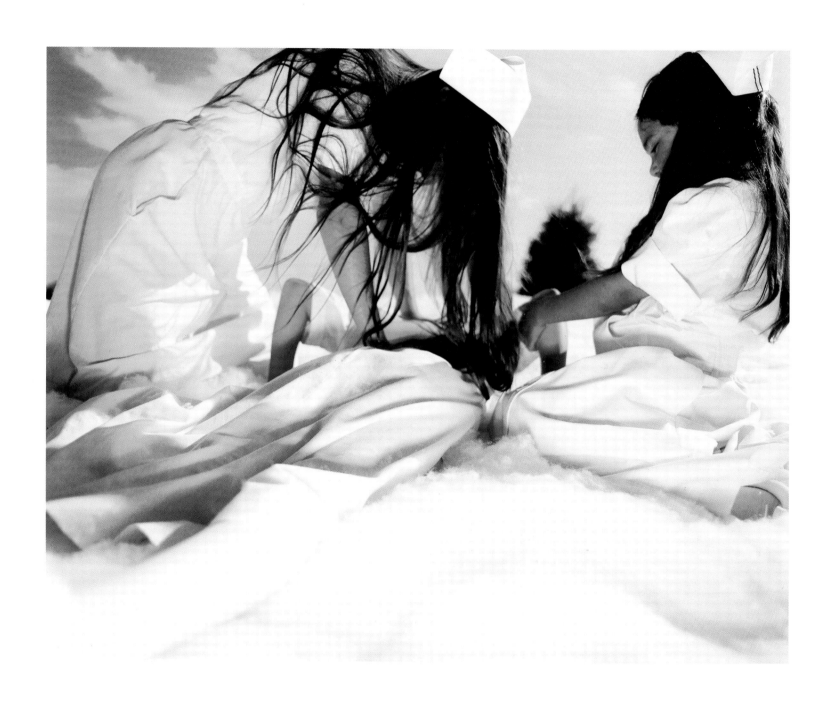

Untitled #62 (by proxy), 1999

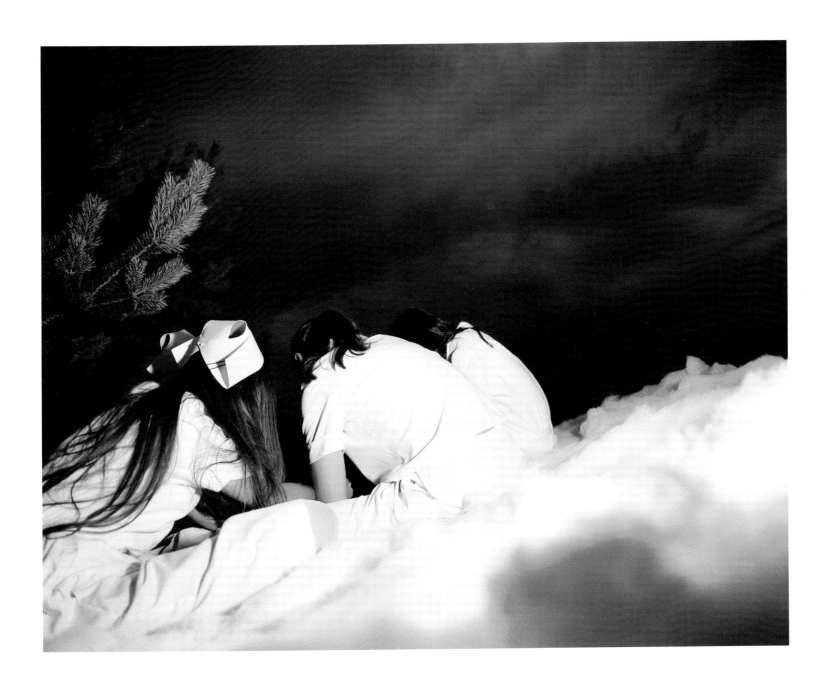

Untitled #63 (by proxy), 1999

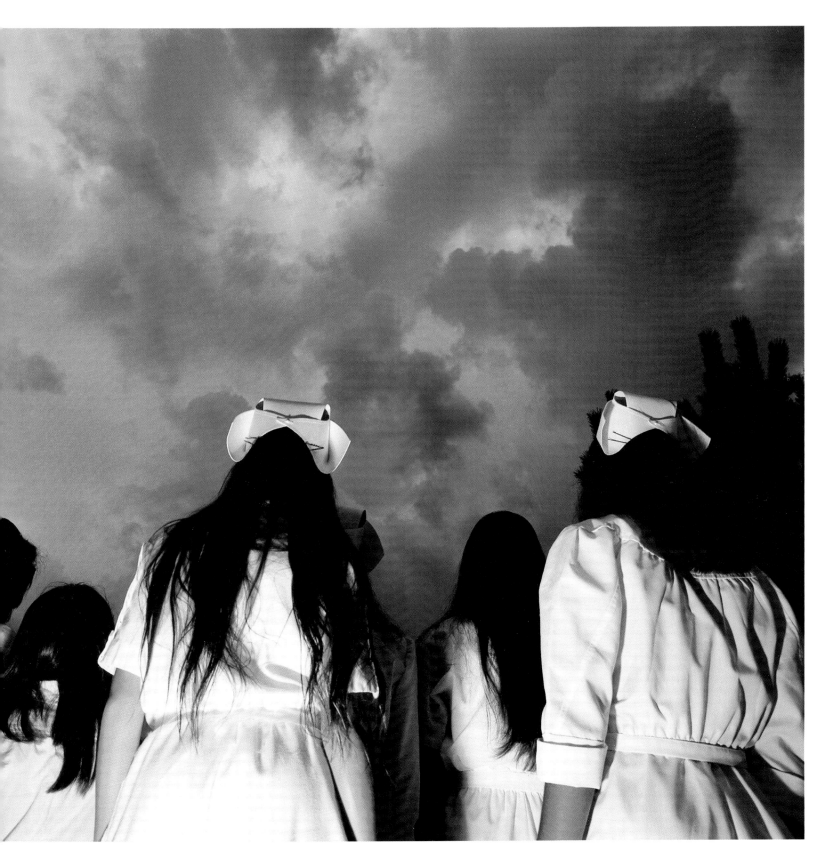

Untitled #64 (by proxy), 1999

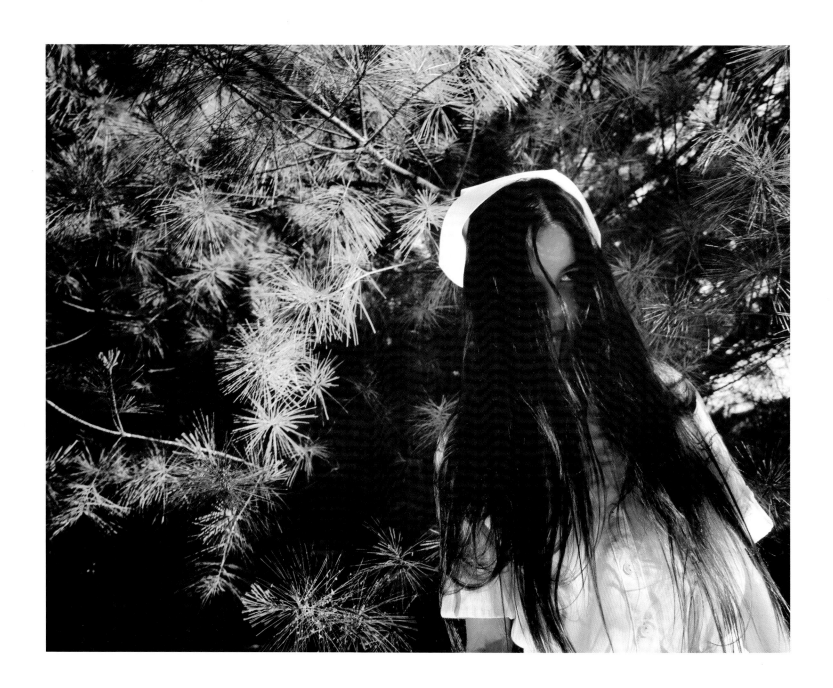

Untitled #65 (by proxy), 1999

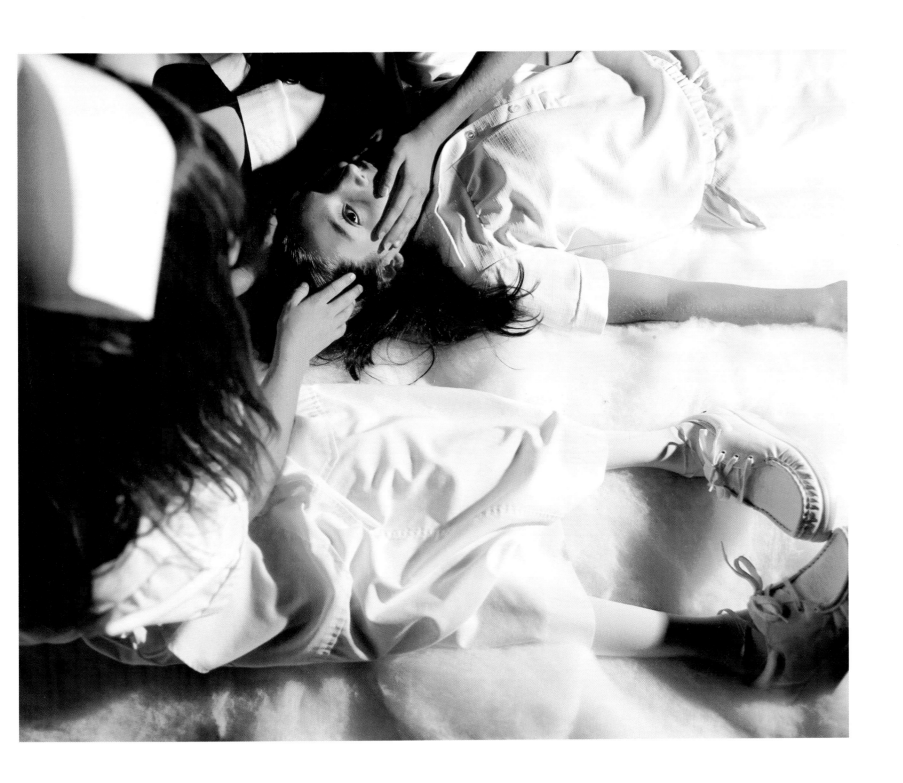

Untitled #66 (by proxy), 1999

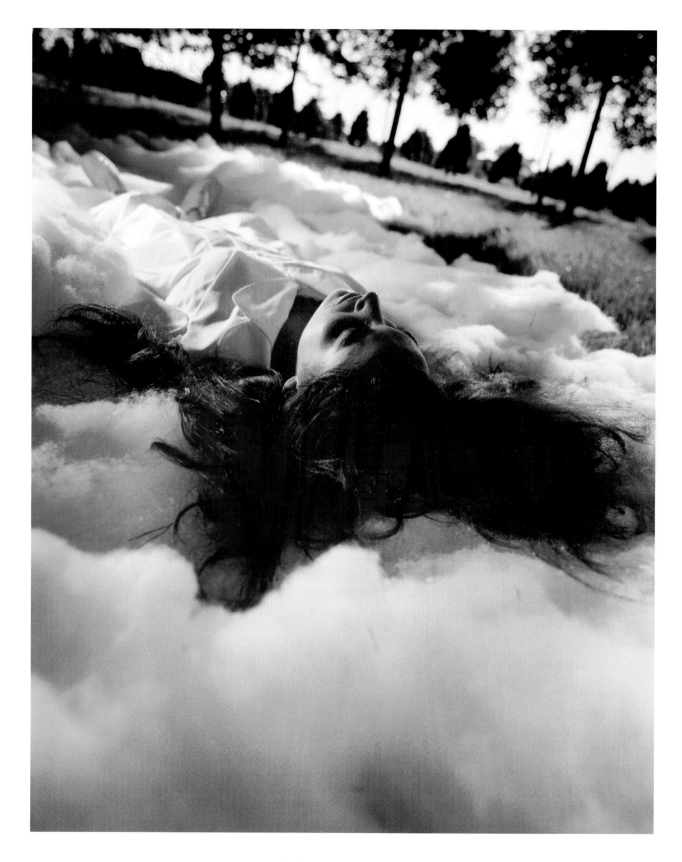

Untitled #67 (by proxy), 1999

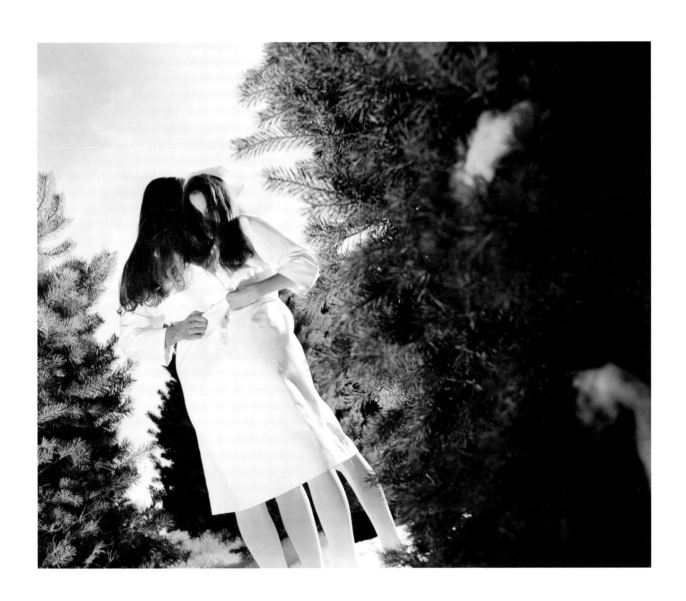

Untitled #68 (by proxy), 1999

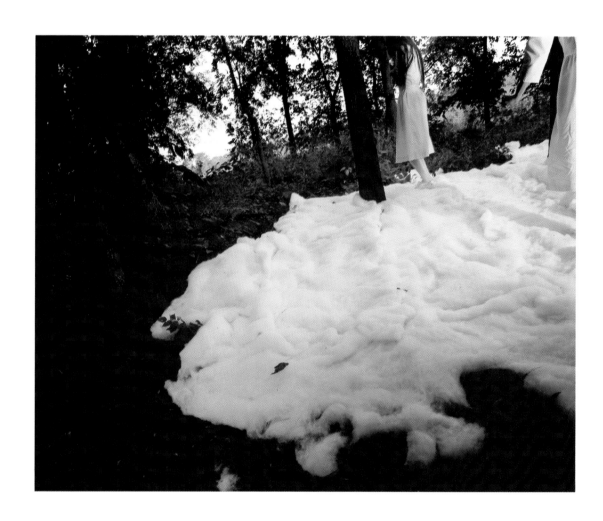

Untitled #69 (by proxy), 1999

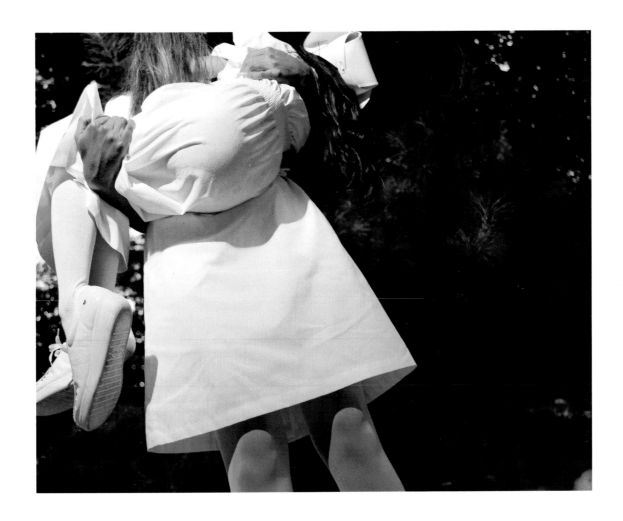

Untitled #70 (by proxy), 1999

Biography

Born 1969 in Des Moines, Iowa
B.F.A., School of the Art Institute of Chicago, 1992
M.F.A., Yale University School of Art, New Haven, Connecticut, 1995
Lives and works in New York and Des Moines

One-Person Exhibitions

1997
Casey Kaplan, New York

1998
Museum of Contemporary Art, North Miami, Florida; traveled to Museum of Modern Art, Oxford, England; Astrup Fearnley Museum of Modern Art, Oslo, Norway; and Hasselblad Center, Göteborg, Sweden

1999
Casey Kaplan, New York
Galerie Gisela Capitain, Cologne, Germany
White Cube, London

Selected Group Exhibitions

1994
Camera Obscura, Betty Rymer Gallery, School of the Art Institute of Chicago

1996
Portraiture, White Columns, New York
Baby Pictures, Bravin Post Lee, New York

1997
Stills: Emerging Photography in the 1990s, Walker Art Center, Minneapolis
Projects–Installations, P.S. 1 Contemporary Art Center, Long Island City, New York
Pagan Stories, Apex Art, New York
Le Printemps de Cahors, Saint-Cloud, France
The Name of the Place, Casey Kaplan, New York
Summer Exhibition, Galerie Anne De Villepoix, Paris
Making Pictures: Women in Photography, 1975–Now, Bernard Toale Gallery, Boston
Anna Gaskell, Cecily Brown, Bonnie Collura, Janice Guy, New York

1998
Global Vision: New Art from the 90s, Part III, Deste Foundation, Athens, Greece
Auf der Spur: Kunst der 90er Jahre im Spiegel von schweizer Sammlungen, Kunsthalle Zurich, Switzerland
Selections from the Permanent Collection, Museum of Contemporary Art, North Miami
Zone, Palazzo Re Rebaudengo, Guarene d'Alba, Italy

Remix, Musée des Beaux-Arts, Nantes, France
Pop Surrealism, Aldrich Museum of Contemporary Art, Ridgefield, Connecticut
Power X-Change, Galerie Gisela Capitain, Cologne
Exterminating Angel, Galerie Ghislaine Hussenot, Paris
Sightings, Institute of Contemporary Arts, London
View One, Mary Boone Gallery, New York

1999

L'Autre Sommeil, Musée d'Art Moderne de la Ville de Paris
Documentary Theater, Joseloff Gallery, University of Hartford, West Hartford, Connecticut
Photography: An Expanded View, Solomon R. Guggenheim Museum, New York; traveled to Guggenheim Museum, Bilbao, Spain
Generation Z, P.S. 1 Contemporary Art Center, Long Island City, New York
Uncanny, Fotomuseum Winterthur, Switzerland

2000

Hypermental, Kunsthaus Zurich
ForWart, Banque Bruxelles Lambert, Brussels
Staged, Bonakdar Jancou Gallery, New York
The Citibank Private Bank Photography Prize 2000, Photographers' Gallery, London
10–6, Casey Kaplan, New York

Selected Bibliography

Avgikos, Jan. "Anna Gaskell." *Artforum* 36 (February 1998): 93.

Bonami, Francesco, and Hans Ulrich Obrist, eds. *Dreams*. Turin: Fondazione Sandretto Re Rebaudengo per l'Arte, 1999.

Cameron, Dan, "Camera Chameleon." *Art News* 98 (May 1999): 148.

Clearwater, Bonnie. *Anna Gaskell*. North Miami, Fla.: Museum of Contemporary Art, 1998.

_____. "Slight of Hand: Photography in the 1990s." *Art Papers* 23 (September–October 1999): 22–27.

Clifford, Katie. "Anna Gaskell." *Art News* 97 (March 1998): 176.

Cohen, Michael. "Anna Gaskell." *Flash Art* 31 (January–February 1998): 101.

Fogle, Douglas. *Stills: Emerging Photography in the 1990s*. Exhibition brochure. Minneapolis: Walker Art Center, 1997.

Frankel, David. "The Name of the Place." *Artforum* 35 (May 1997): 104.

Gaskell, Anna. "Top Ten." *Artforum* 38 (June 2000): 54.

Grant, Simon, and Elizabeth Janus. *The Citibank Private Bank Photography Prize 2000*. London: Photographers' Gallery, 2000.

Mahoney, Robert. "Anna Gaskell's 'wonder.'" *Artnet.com* (Internet magazine), 16 December 1997.

Muir, Robin. "Child's Play." *Independent Magazine*, 12 February 2000, 18–19.

Pollock, Barbara. "Lights, Action, Camera!" *Art News* 99 (February 2000): 126–31.

Princenthal, Nancy. "Generation Z: Slacker than Thou." *Art in America* 87 (October 1999): 90–91.

Smith, Roberta, "The World through Women's Lenses." *New York Times*, 13 December 1996.

Yablonsky, Linda. "Casey Kaplan Shows Anna Gaskell." *Art and Auction* 22 (15 November 1999).

Board of Trustees: Susan Marx, President; Nancy Magoon, Vice President; Joyce Gruenberg, Co-Treasurer; Tom Sharkey, Secretary; Bob Sullivan, Co-Treasurer; Randy Beier, Barbara Broeder, Laurie Crown, Charles Cunniffe, Holly Dreman, Richard Edwards, Nancy Epstein, Jill Fink, Ana Goldberg, Jane Jellinek, Tony Mazza, Dick Osur, Ed Roth, Susan C. Walker, Betty Weiss, Lorrie Winnerman, Arthur C. Daily, Esq., of counsel

Trustees Emeritus: Roberta Allen, Diane Anderson, Laura Donnelley-Morton, Merrill Ford, Mary Jane Garth, Al Glickman, Marty Kahn, Alan Marcus, Laura Thorne

National Council: Sylvia and Richard Kaufman, Co-Chairs; Peggy and Charles E. Balbach, Vice-Chairs; Diane Anderson, Harley Baldwin and Richard Edwards, Anne Bass, Barbara and Bruce Berger, Marie and Robert Bergman, Jill and Jay Bernstein, Barbara S. Bluhm and Don Kaul, Kay and Matt Bucksbaum, Melva Bucksbaum, Dale Coudert, Mary H. Dayton, Frannie Dittmer, Holly and David Dreman, Suzanne Farver, Nanette and Jerry Finger, Kathryn Fleck, Merrill Ford and Robert Taylor, Rosemary and Richard Furman, Mary Jane Garth, Gideon Gartner, Linda and Bob Gersh, Judy and Al Glickman, Audrey and Arthur Greenberg, Jan and Ronald K. Greenberg, Lundy and Jim Hedges, Lita and Morton Heller, Phyllis Hojel, Ann and Edward R. Hudson, Jr., Holly Hunt, Fern Hurst, Jane and Gerald Katcher, Susan and Bruce Konheim, Pamela and Richard Kramlich, Toby Devan Lewis, Marilyn and Donn Lipton, Cornelia and Meredith Long, Marianne and Sheldon Lubar, Nancy and Robert Magoon, Marlene and Fred V. Malek, Nancy and Peter Meinig, Gail and J. Alec Merriam, Gael Neeson and Stefan T. Edlis, Judith Neisser, Ann and William Nitze, Linda Pace and Laurence Miller, Pat and Manny Papper, Julia and Waring Partridge, Lynda and Stewart Resnick, Mary and Partick Scanlan, Gloria and Howard Scharlin, Danner and Arno D. Schefler, Barbara and F. Eugene Schmitt, June and Paul Schorr, Barbara and Robert Shook, Shirley and Albert Small, Julie and Barry Smooke, Gay and William T. Solomon, Ginny Williams, Ruth and Herb Winter, Rosina Lee Yue and Bert A. Lies, Jr., Harriet and Jerome Zimmerman

Museum Staff: Dean Sobel, Director; Mary Ann Igna, Associate Director; Susan Claire Burston, Director of Development; Dara Coder, Controller; David Marsh, Exhibition Preparator; Cathleen Murphy, Registrar; Kat Parkin, Education Coordinator; Christy Sauer, Development Assistant; Kate Wheeler-Vanderburg, Membership Coordinator; Linda Whisman, Graphic Designer/Office Manager